T0273134

Behind Every
GREAT
WOMAN
is a
GREAT
CAT

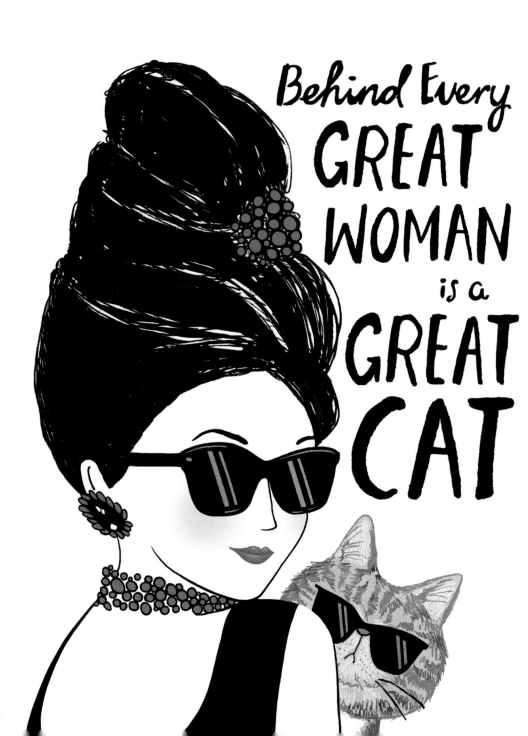

Behind Every GREAT WOMAN is a GREAT CAT

ILLUSTRATED BY
LULU MAYO

WRITTEN BY JUSTINE SOLOMONS-MOAT

Published in North America in 2020 by Get Creative 6, an imprint of Mixed Media Resources,
19 West 21st Street, Suite 601, New York, NY 10010
Connect with us on Facebook at facebook.com/getcreative6

First published in Great Britain in 2019 by LOM ART, an imprint of
Michael O'Mara Books Limited, 9 Lion Yard, Tremadoc Road, London SW4 7NQ

Library of Congress Cataloging-in-Publication Data

Names: Solomons-Moat, Justine, author. | Mayo, Lulu, illustrator.
Title: Behind every great woman is a great cat / illustrated by Lulu Mayo ;
written by Justine Solomons-Moat.
Description: New York : Get Creative 6, an imprint of Mixed Media
Resources, 2020. | Summary: "The uplifting stories of more than 30
cat-loving women-artists, pioneers, writers, and humanitarians -who
dared to change and inspire the world are paired with Lulu Mayo's quirky
illustrations. These inspiring cat ladies include Florence Nightingale
(the founder of modern nursing), Georgia O'Keeffe (the artist and mother
of American modernism), and Rosa Luxemburg (the theorist and
revolutionist). The book celebrates the cat as muse, companion,
colleague, and emotional support as it explodes the myth of a "cat
lady." Tips for how to act like your cat, quotes from famous women who
loved their kitties, and more round out this fabulous gift book"--
Provided by publisher. 36.8--dc23
Identifiers: LCCN 2019034184 | ISBN 9781684620067
Subjects: LCSH: Cat owners--Women--Anecdotes. | Cats--Anecdotes.
Classification: LCC SF442.7 .S65 2020 | DDC 6
LC record available at https://lccn.loc.gov/2019034184

4 6 8 10 9 7 5 3

Printed in China

CONTENTS

Woman's Best Friend

Explore the myriad relationships between woman and cat and discover those who have dared to change and inspire the world.

Artists, pioneers, writers, humanitarians—women from all walks of life have celebrated their cat companions as muse, model, grounding influence, and steady support. Explore the stories of fascinating women who have shaped history, with their faithful feline companions by their sides.

Along the way, learn lessons for life from a cat's perspective, discover some record-breaking cats in the Hall of Fame, and take a test to find your purr-fect feline match.

Cats have long been considered valued companions, bringing inspiration and camaraderie to the lives they touch. This book will show you that behind every great woman is an equally fabulous feline.

Georgia O'Keeffe
—— ARTIST ——

Is there a more perfect pairing than artist and cat? Both are often regarded as aloof, enigmatic, and mysterious, so it's no surprise that many artists throughout the ages have worked with a cat by their side. Trailblazing painter Georgia O'Keeffe was no exception.

Born into a farming family in Wisconsin, Georgia moved to New York City in 1918 to pursue a career as an artist. There, she created a series of skyscraper paintings, as well as her now-famous large-format, close-up paintings of flowers. One day, a visiting art critic handed Georgia a stray white kitten, whom she adopted and named Long Tail.

Georgia made regular visits to New Mexico, moving there permanently in 1949, where she painted the rugged desert and continued to keep cats. One particularly feisty feline would catch rats and eat only the heads. As a dutiful cat owner, Georgia collected the half-rats and kept them in the fridge to later feed to the kittens.

IS THERE A MORE PERFECT PAIRING THAN ARTIST AND CAT?

Georgia holds the record for the highest price paid for a piece painted by a woman, an astounding $44.4 million, and was the first woman to be granted a solo retrospective exhibition at the Metropolitan Museum of Art in New York. Of her status, she said, "Men like to put me down as the best *woman* painter. I am one of the best *painters*."

Georgia spent her later years surrounded by cats. One poignant photograph shows her smiling into the camera as she lovingly strokes a Siamese perched on her shoulder.

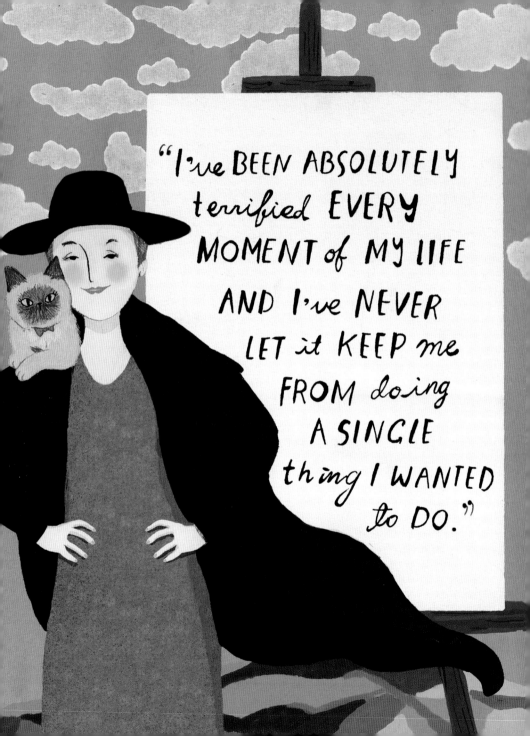

Mae Jemison
── Engineer ──

As a little girl growing up in Chicago, Mae Jemison would often gaze up into the night sky and dream of journeying among the stars. Fast-forward 30 years and Mae found herself looking down on Chicago from the inside of a NASA space shuttle. What inspired Mae to pursue her childhood ambition? She credits cats as one of her motivations, observing that they are very determined and know precisely what they want to do.

"Determined" could well have been Mae Jemison's middle name. She started studying at Stanford University from the age of 16 and trained as a doctor before joining the Peace Corps. After being accepted into NASA's astronaut program in 1987, Mae became the first woman of color to travel in space just five years later.

"I WOULD HAVE BEEN HAPPY IF MY CAT, SNEEZE, WAS THERE."

Reflecting on her historic flight, Mae had just one regret. She thought that she would be afraid and that she'd be happy to have other people there for reassurance, but she realized what would have really made her happy was if her cat, Sneeze, had been there, too.

After retiring from NASA, Mae founded her own technology company, became a college professor, and later enjoyed success as a writer. Despite becoming astronomically successful, Mae still hopes to return to space, only this time, she has one important condition: her cat companion has to join the mission.

SUNDAY REED
—— ART COLLECTOR ——

As a passionate collector of Australian art, Sunday Reed is considered one of the most important figures in modern Australian culture. She helped to shape Australian art of the early 20th century by establishing a public art museum and nurturing many emerging artists.

Along with her husband, John, Sunday gave support and patronage to painters, sculptors, and writers. The couple's home, Heide, became a gathering place for artists to meet, talk, and work. The so-called "Heide Circle" included painters Sidney Nolan, Joy Hester, and Albert Tucker.

As well as being an artists' haven, Heide was also a haven for cats. Sunday built a large cattery, known as the "Cat Château," to house her many felines. The Château even had specially designed windows that had cat flaps so the felines could roam at leisure. Sunday treated its residents like royalty and even provided the cats with the finest catnip, secretly sourced from a curator via Kew Gardens in London. A keen gardener, Sunday had a number of contacts who helped her to source rare seeds from overseas. Import customs were very strict and, as such, Sunday regularly partook in illicit "seed-smuggling." This included secretly importing catnip seeds from the other side of the world. She went to extreme lengths to keep her cats happy.

HEIDE WAS ALSO A HAVEN FOR CATS.

Sunday collected almost as many cats as she did artworks, owning as many as 20 felines at one point. Despite having several pedigree Siamese cats, Sunday was a sensitive soul and could never resist taking in a stray or two.

Sunday's former home is now the Heide Museum of Modern Art in Melbourne, and it welcomes thousands of art aficionados every year. Visitors to the house can still see the Cat Château that remains in its garden to this day.

Jacinda Ardern
— Prime Minister —

When the Prime Minister of New Zealand attended a dinner at Buckingham Palace in the spring of 2018, something was unusual. Was it because, at just 37 years old, Jacinda Ardern was the world's youngest female head of government? Possibly. Was it because she was seven months pregnant at the time? Maybe. Or was it because the corgi-loving Queen had let a self-confessed cat lover into her home? Definitely.

IT'S NO SURPRISE THAT JACINDA CHOSE A PET AS REMARKABLE AS HERSELF.

The country that she leads may be small, but Jacinda's impact on politics is big. She is among the few women who are world leaders and is only the second elected head of government to have given birth while in office.

It's no surprise that Jacinda chose a pet as remarkable as herself. Paddles, an orange-and-white rescue cat, was polydactyl—meaning she had an unusual number of toes—and appeared to have opposable thumbs. Paddles even had her own Twitter account, and there were rumours that she was responsible for running it! But that really would have taken the term "great cat" to a new level.

When one world leader phoned to congratulate Jacinda on her election victory, Paddles chose that moment to burst into the room, jump up beside Jacinda, and begin meowing loudly. Seemingly, the cat had not inherited her owner's skills in diplomacy and international relations.

"I've lived as a CAT LADY,
I'm HAPPY to BE a CAT LADY.
I'll continue to be a CAT LADY.
Just bring them ALL to my HOUSE
and I'll keep them ALL, no PROBLEM."
— Hannah Simone, Actor

Clara Barton
—— Humanitarian ——

Clara Barton was a fearless nurse and passionate humanitarian whose tireless dedication to others earned her the epithet "the angel of the battlefield."

Clara cared for soldiers and delivered critical medical supplies during the American Civil War and the Franco-Prussian War in the 1800s. She founded the American Red Cross in 1881 and was its president for over 20 years. In 1898, at the age of 77, she headed to the battlefield of the Spanish-American War, refusing to let age get in the way of helping people.

Most people who show great bravery on the battlefield are acknowledged with medals, but Clara Barton is probably the only person to have been awarded a kitten. Congressman, and future Vice President of the United States, Schuyler Colfax sent Clara the unusually fluffy honor, complete with a bow around its neck, to thank her for the important part she played at the Battle of Antietam during the American Civil War.

It is clear that Clara absolutely adored her new cat, whom she named Tommy. The black-and-white feline was her companion for 17 years, and Clara described him as a faithful friend. She considered Tommy to be a member of the family and even had an oil painting of him on display in her dining room, painted by fellow nurse and friend

> **CLARA BARTON IS PROBABLY THE ONLY PERSON TO HAVE BEEN AWARDED A KITTEN.**

Antoinette Margot. Clara's home has since become a museum, and visitors can still see the picture hanging in pride of place. For Clara, cats were as deserving of love and attention as the humans that were in her care.

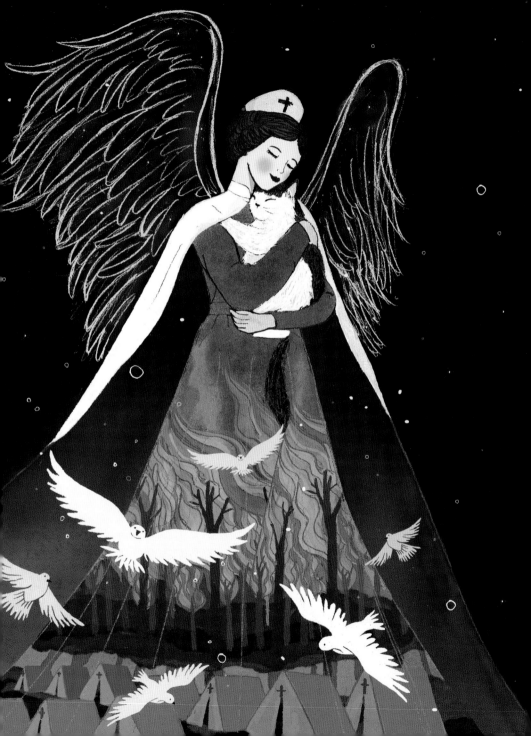

ZOË FOSTER BLAKE
— ENTREPRENEUR —

Zoë Foster Blake has a confession to make: she suffers from a terrible case of what she calls "chronic over-busyness." And it's not difficult to see why. By the time she reached her thirties, the journalist-turned-entrepreneur was involved in a number of endeavors.

Zoë has penned lifestyle columns for *Cosmopolitan* and *Harper's Bazaar*, run a successful beauty blog, written ten books, developed a life-coaching app, launched a skincare line, and amassed hundreds of thousands of Instagram followers in the process.

MEOWBERT GETS MORE ATTENTION THAN HER BEAUTY POSTS.

With her trademark approachable style, sense of humor, and ability to simplify the often intimidating world of beauty, Zoë has quickly become one of Australia's leading figures in the industry.

However, although it may seem that Zoë's days are full of endless glamour, the reality of life as a writer and business owner is somewhat different. She spends most of her time at home with her workmate, a cat called Meowbert. He is a long-haired orange Persian and star of Zoë's social media accounts. With his squashy face and a tongue that lolls out of his mouth, the cat is adored by Zoë's followers—sometimes Meowbert gets more attention than her beauty posts. Snaps of him lying across her laptop and snoozing in funny positions have been liked tens of thousands of times.

With his luscious locks, perfect poses, and cult following, it's easy to tell who the real beauty icon is in the Foster Blake household.

JULIA CHILD
—— CHEF ——

Julia Child was a chef, writer, and TV personality credited with bringing French cuisine to a mass audience through her books and shows. Yet, she only learned to cook in her thirties, when she moved to Paris with her husband. When they discovered they had a mouse problem in their new home, their maid brought them a cat to deal with it. They named the cat Minette—Mini for short—and the Child family was complete.

MINETTE WOULD STALK THE KITCHEN, READY TO POUNCE ON ANY DROPPED INGREDIENTS.

Talking about Minette, Julia admitted that she had never been much of an animal person. However, Julia declared her first cat "marvelous!" Minette served as Julia's sous-chef, often being the first to sample her culinary creations. When Julia hosted cooking classes at home, Minette would stalk the kitchen, ready to pounce on any dropped ingredients. She would eat anything and especially enjoyed saucers of mushroom soup.

Julia's kitchen is considered such an iconic piece of American culture that it is now displayed in the Smithsonian National Museum of American History. She donated it in 2001 and it remains stocked with the essentials any good chef needs: pots, pans, and an extensive collection of cat ornaments.

Take one adventurous American woman, place her in Paris, and add one cat, and you will have the perfect recipe for the life of a great culinary cat lady.

YOKO ONO
—— ARTIST ——

In a career spanning six decades, Japanese artist Yoko Ono has created radical music and performance art, while also campaigning tirelessly for peace and human rights.

Yoko was married to John Lennon, the singer-songwriter and co-founder of The Beatles phenomenon, with whom she shared a mutual appreciation for cats. In their time together, the couple owned seven felines, whom they loved deeply, including two gorgeous Persians and a black-and-white pair called called Salt and Pepper. Of course, they weren't named as you'd expect; the black cat was named Salt and the white one was called Pepper.

Yoko doted on all of their cats. She admired the class and elegance of the Persians and talked fondly of Charo, a cat of indistinguishable breed, whom John described as having a funny face. On one occasion, Yoko and John got up in the middle of the night to make tea. When they entered the kitchen, they were greeted by their three beloved cats—Charo, Sasha, and Micha—in the kitchen, all sitting on the counter. The cats watched Yoko and John expectantly while they puttered around the kitchen brewing tea, each waiting to be petted. They weren't going to miss out on the midnight tea round.

> **YOKO FOUND KINDRED SOULS IN FELINES THAT REFUSED TO CONFORM.**

As a spirited, independent, and often misunderstood woman, it may be that Yoko found kindred souls in felines that refused to conform.

10 Things
YOU CAN LEARN FROM CATS

Every woman featured in this book is inspiring in her own way, and from them you can learn lessons in perseverance, passion, and pride. But behind every great woman is a great cat, so what can cats teach you about greatness?

1. BE INDEPENDENT

"Where's the cat?" is a common refrain in a household with cats. No one ever knows the answer because, like all great people, cats follow their own path and don't ask permission. They are the four-legged masters of their own furry fates.

2. BE SLEEPY

In sleepiness lies greatness. While it's sadly not practical for two-legged folk to doze for up to 15 hours a day, humans can still take note from cats. Getting a healthy eight hours a night will ensure you're ready to take on the world.

3. BE DEMANDING

Picture the scene: you've found the comfiest, coziest spot on the sofa. You leave momentarily to make a cup of tea, only to return to find your purr-fect place has been pinched by a feline sofa-pilferer. All great people are like cats in this way: they know what they want from life and seize it. Don't take no for an answer.

4. BE PLAYFUL

Behold the cat—regal ruler of the living room. Cool and collected. Demure and dignified. Refined and ... wait, what's that? A piece of string? The living room will have to rule itself for a bit. Cats know that in order to stay great they need to take a break once in a while and kick back with some catnip.

5. BE READY TO SHOW YOUR CLAWS

A pussycat may appear to be a big softy, but hidden underneath the furry exterior are wicked claws ready to be used. To be great, you need to be prepared to stand up for yourself when needed. Humans please take note: scratching is never an acceptable form of defense.

6. BE SELF-CARING

With a hectic schedule of nap after nap and back-to-back belly rubs, it's important to book in some much-needed "me" time. Cats have self-care sorted, with their strict grooming regime. Great people, like cats, take care of number one. Make sure you treat yourself to a good pampering session once in a while. Just don't try to lick yourself clean.

7. BE KIND

Whether they're rubbing up against a stranger's leg or curling up in a loved-one's lap, cats give their love generously, without judgment, and treat everyone equally. We can all take something from that.

8. BE MYSTERIOUS

Many cultures have worshipped cats and even considered them to be divine. One can only assume that cats would find this entirely appropriate. It's possible felines have been thus revered as a result of their enigmatic air and silent omnipresence. Great people often have a certain mystery about them. Why not try to be more enigmatic, like a cat? Dress completely in black, slink soundlessly into a room, crawl atop a cupboard—it's bound to get people talking.

9. BE SCARED OF SOMETHING

Everyone knows that water, vacuum cleaners, and cucumbers are understandably and utterly terrifying to cats. Being a scaredy-cat often gets a bad rep, but it's a perfectly normal reaction and a way to protect ourselves from danger. Great people have often harnessed fear and used it as motivation to achieve their goals.

10. ALWAYS LAND ON YOUR FEET

From time to time in life, we will fall. Sometimes we'll do it spectacularly. Sometimes we'll do it in public places. In these moments we should consider cats and how they always manage to land on their feet. It's a good metaphor for adapting, recovering, and moving on. Sure, it helps when you have four feet, but give it a go.

COLETTE
—— AUTHOR ——

Born in Paris in the late 19th century, success did not come easily to Sidonie-Gabrielle Colette. Her first husband, Henri Gauthier-Villars, exploited her incredible talent as a writer and forced her to write books that he then took and attributed to his name.

Despite this, Colette fought fiercely for her independence and the right to write her own destiny, managing to leave Gauthier-Villars in 1906. Despite her novels being wildly popular, she had to work hard to keep poverty at bay, while Gauthier-Villars kept all the royalties from the books she had written during their time together. While working as a music hall performer, Colette continued to write, penning numerous novels, short stories, and essays, often on the subject of love. In 1927, she was dubbed the greatest living writer in France and went on to be nominated for the Nobel Prize in Literature in 1948.

Among her masterpieces, Colette wrote a short novel, *La Chatte,* featuring a cat at its center. The author was besotted with felines, owning several cats herself and often giving them cameos in her stories. Her beautiful white cat Fanchette features in *Claudine à Paris*, the gray Angora Kiki-la-

> **"TIME SPENT WITH CATS IS NEVER WASTED."**

Doucette can be found in *Dialogues de Bêtes* and the blue Chartreux Saha has a star turn in the aforementioned *La Chatte*. When Colette's novel *Gigi* was adapted for the theater, she was given the chance to handpick her leading lady. Is it any surprise that she cast fellow cat lover Audrey Hepburn?

Colette is believed to have said that "time spent with cats is never wasted." And few would disagree with a Nobel Prize nominee.

ROSA LUXEMBURG
—— REVOLUTIONARY ——

Revolutionary. Rule breaker. Rebel. These are the terms that are often used to describe Rosa Luxemburg. However, the world-changing woman nicknamed "Red Rosa" had a softer side, which she reserved for her beloved cat, Mimi.

Rosa was a Polish-born German philosopher and activist, considered to be one of the greatest political thinkers in history. She played a key role in the socialist movements in Germany and Russia in the late 19th and early 20th centuries. But Rosa was criticized and imprisoned as a result of her beliefs and she also faced discrimination due to her gender and physical disability, having been born with a limp. In tough times, Rosa turned to her cat for comfort and companionship. She felt she could always rely on Mimi to guide her to the right path with a knowing look. In a sign of her deep affection, Rosa sometimes referred to Mimi as her daughter.

IN TOUGH TIMES, ROSA TURNED TO HER CAT FOR COMFORT AND COMPANIONSHIP.

Like her owner, Mimi was highly intelligent and could often be found mingling with notable political figures. Mimi once met Russian revolutionary Vladimir Lenin, who described Mimi as a "magnificent creature" and *baskii kot*, meaning a "majestic cat" in Russian. Although they had a mutual respect for each other, Rosa didn't always agree with Lenin's ideas, and it seemed Mimi didn't either. When he tried to pet the cat, Mimi swiped him with her paw and snarled at him. Together they made the purr-fect pair—Red Rosa and her political pussycat sidekick.

VIVIEN LEIGH
— ACTOR —

"When I leave school," Vivien Leigh declared, when she was just a little girl, "I am going to be a great actress." This determined child followed through on her dreams, growing up to be one of the biggest Hollywood stars of all time. Vivien was a relatively unknown young English actor when she was cast in a film called *Gone with the Wind*. It became a blockbuster, winning ten Academy Awards, including a Best Actress trophy for Vivien, who became the first British performer to ever receive one. Vivien went on to star in several more successful Hollywood films, such as *Anna Karenina* and *A Streetcar Named Desire*, as well as stage productions on Broadway in New York and in London's West End.

Vivien was once described as elegant and composed, just like a small Siamese cat. This was rather fitting given that Vivien confessed to being mad about cats from an early age, when she kept them at boarding school. She owned several cats in later life, including Tissy, a black-and-white adopted stray, and Siamese cats New Boy, Armando, and Poo Jones. Siamese cats were Vivien's favorite breed. She once said, "They make wonderful pets and are so intelligent they follow you around like little dogs."

THE CATS EVEN ACCOMPANIED VIVIEN IN HER ROLLS-ROYCE.

Vivien's cats did indeed follow her everywhere. She took New Boy with her to the set of *Anna Karenina,* and Poo Jones would sleep in her theater dressing room while she performed on stage. The cats even accompanied Vivien in her Rolls-Royce. It has been suggested that Vivien kept cats for their calming effect, as she suffered from periods of poor mental health. Whatever the reason, it seems that these elegant felines perfectly suited this silver-screen siren.

ELIZABETH OF RUSSIA
—— EMPRESS ——

The year was 1745, and Elizabeth Petrovna, Empress of Russia, was facing one of the most troubling issues of her reign: how to deal with the mice that had overrun the imperial palace in St. Petersburg. Suddenly, a solution came to the young queen—she would create a cat army.

The monarch swiftly issued a royal decree to find the biggest and the best cats in Russia to assume these crucial mouse-catching duties. The cats were to be sent immediately to the court of her Imperial Majesty, along with someone to look after them and feed them.

PERHAPS HER MOST ENDURING LEGACY IS HER ROYAL CAT COLONY, STILL PURRING OVER 270 YEARS LATER.

A feline fighting force took up residence in the Winter Palace—and has been there ever since. Today, around 70 cats are estimated to live in the palace, which is now a museum. Elizabeth would be pleased to hear that they spend their days purring contentedly, cared for by dedicated staff, petted all day by visitors, visiting the on-site cat hospital if they get ill—and occasionally deigning to catch the odd mouse.

Reigning for 20 years, Elizabeth was one of Russia's most popular monarchs, leading her people through two major conflicts and establishing the country's first university. Yet perhaps her most enduring legacy is her royal cat colony, still purring over 270 years later. Behind every great Empress is a great cat ... or 70.

FELINE FLOWCHART

Take this test to find out which cat breed would best serve you as your loyal sidekick. Read all about your feline personality in more detail on the next page.

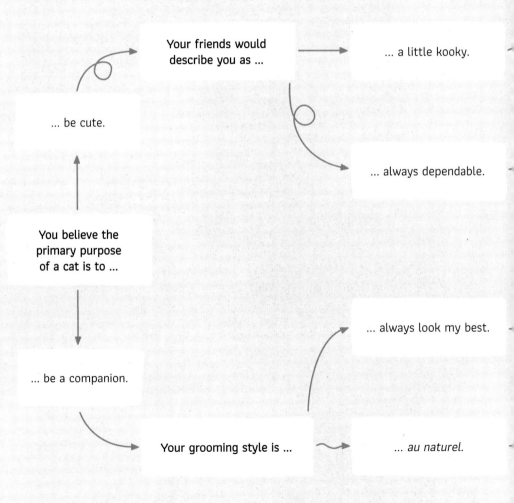

... be cute.

Your friends would describe you as ...

... a little kooky.

... always dependable.

You believe the primary purpose of a cat is to ...

... always look my best.

... be a companion.

Your grooming style is ...

... *au naturel.*

Your ideal getaway would be ...

... a cozy cabin in the woods.

... a luxury city hotel.

SCOTTISH FOLD

At a party you'd most likely be ...

... on hosting duties.

... organizing entertainment.

SIAMESE

Masquerade ball or fluffy onesie?

Masquerade ball.

Fluffy onesie.

MAINE COON

Would you rather be extremely hairy or have no hair at all?

Extremely hairy.

No hair.

SPHYNX

FELINE FLOWCHART:
YOUR CAT COMRADE

Discover the personality behind your purr-fect feline companion.

— SCOTTISH FOLD —

Your purr-fect pet is a Scottish Fold. With floppy ears that fold over toward its face and large, owl-like eyes, this is one kooky and utterly adorable feline. Its cute ears are the result of a genetic mutation, but the Scottish Fold is so much more than a pretty face. It is known for being a loyal and constant companion to its owner. Just like the Scottish Fold, you are completely dedicated to your family and friends—*and* totally gorgeous.

— SIAMESE —

You should be feline good, because your paw-some pairing is the Siamese. One of the most elegant of all breeds, this cool cat has bags of style and a distinguished heritage that has been traced all the way back to 14th century Siam (modern-day Thailand). Its intelligence, sociable personality, and active manner have made the Siamese a very popular pet. You will find a kindred spirit with a Siamese, as you both share an energetic nature and extroverted personality.

— MAINE COON —

Make way for the Maine Coon. One of the largest breeds around, the Maine Coon packs a powerful presence. Known as "America's native cat," this feline originated from rural farms where it excelled at catching mice. With its thick, shaggy coat and bushy tail, it's not hard to see why this cat was once mistaken for being part-raccoon. But don't let its rugged looks fool you—an adult Maine Coon still acts like a playful kitten. This cat's love of the outdoors and its adventurous, youthful personality, makes it your ideal match.

— SPHYNX —

Your feline match is a Sphynx cat. With its striking appearance, heads won't fail to turn when a Sphynx slinks into a room. This peculiar-looking pussycat is instantly recognizable by its hairless, wrinkled skin and large, bat-like ears. Its uniqueness may mean that it's not everyone's cup of tea, but the Sphynx doesn't give a whisker. Those who make the effort to get to know the Sphynx are rewarded with endless affection and love. Like the Sphynx, you have an instant impact on all those you meet and make friends for life.

TAYLOR SWIFT
—— MUSICIAN ——

Cameras flashed as Taylor Swift stepped onto an awards ceremony red carpet in Los Angeles in 2015. Taking one look at the singer in her floor-length teal gown, a journalist remarked that Taylor might be taking a man home that night as well as a trophy. She flashed back that she wasn't going to walk home with any men—she was going to hang out with her friends and then go home to her cats. Taylor is clearly a young woman unafraid to speak her mind ... and one utterly besotted with her cats.

Two of Taylor's purr-fect felines are named after her favorite TV characters, Dr. Meredith Grey and Detective Olivia Benson. Her Scottish Fold cats accompany her on tour, traveling in bespoke carriers embroidered with their names naturally. The singer's fans regularly bring posters to her concerts bearing giant pictures of Meredith's and Olivia's faces for Taylor to sign.

MEREDITH, OLIVIA, AND BENJAMIN ARE SOME SERIOUSLY SASSY VIP FELINES.

This furry celebrity duo is regularly featured on Taylor's Instagram page and garners millions of likes from fans all over the world. There has even been Meredith and Olivia merchandise available to buy, ranging from pajamas to necklaces featuring these furry felines.

A new kitten, called Benjamin Button, was welcomed into the fold in 2019. Taylor met him on the set for a music video and immediately fell in love. Taylor says he adores his older sisters, and they look like "marshmallows jumping on each other" when they play.

Meredith, Olivia, and Benjamin are some seriously sassy VIP felines, living a life filled with love, luxury, *and* Taylor Swift.

ANNE FRANK
—— DIARIST ——

Anne Frank wasn't supposed to tell anyone that her family was going into hiding, but she made an exception in order to say goodbye to her pet cat, Moortje. She made sure that Moortje would be well looked after in her absence, leaving him in the care of neighbors. The diary that Anne kept in the years that followed, later published as *The Diary of a Young Girl*, provides a powerful, personal account of growing up in the Netherlands during World War II.

Anne captured the daily lives of her family and other Jewish occupants of the "Secret Annex" in a warehouse office in Amsterdam, where they were hiding from persecution from the Nazis. As well as writing about the people with whom she shared the Annex, Anne often mentioned its feline residents: Boche, a feisty warehouse and office cat, and Mouschi, who belonged to one of the other occupants, Peter van Pels.

The two cats figuratively left their paw prints all over Anne's diary. She wrote about the practical benefit of them catching rats that tried to eat the families' precious food supplies. Anne also recorded a variety of funny cat anecdotes. In one entry, she

CATS FIGURATIVELY LEFT THEIR PAW PRINTS ALL OVER ANNE'S DIARY.

recounted a story about Mouschi accidentally relieving herself over a hole in the floorboards to the side of her litter tray. The ensuing chaos saw Anne in hysterical laughter, and soon after that, umbrellas were required in the Annex to protect against "household showers" as Mouschi got into the habit of weeing between the cracks in the floorboards.

The cats undoubtedly provided Anne with stories for her diary, as well as a much-needed source of entertainment, normality, and comfort during a time of great danger and uncertainty.

REMEDIOS VARO
—— ARTIST ——

Many great artists in the course of history, from ancient Egyptian craftsmen to contemporary artists, have chosen to study, sculpt, and sketch cats. However, no artist has painted pussycats quite like Remedios Varo. The quirky Spanish-Mexican painter believed she had been a cat in a past life, which may explain why she favored felines so much. Remedios owned many cats, which she described as her personal allies.

CATS WERE VERY OFTEN A MUSE FOR REMEDIOS.

The surrealist artist was famed for her intriguing paintings of mythical creatures and mysterious scenes. Cats were very often a muse for Remedios, whether she portrayed them cavorting in a forest clearing in *The Cats' Paradise* or as a strange feline-plant hybrid creature in *The Fern Cat*. Perhaps her most powerful pussycat painting is *The Madness of the Cat*, which shows the bond between a woman and her cat. A ginger cat has leapt up onto the table and knocked a glass of water off it. Despite this, the woman is stroking the cat and their contact is producing sparks of energy flying off into the room. The woman also has ginger hair and skin and three furry paws poke out from under her skirt, where her feet should be. Explaining the chaotic scene shown in the picture, Remedios said the cat had jumped onto the table and caused the sort of disorder that you must learn to tolerate if you like cats, as she did.

Remedios formed a close friendship with fellow artist and cat-lover Leonora Carrington. In Leonora's semi-autobiographical book, *The Hearing Trumpet*, Remedios is portrayed as a kindly old lady who takes care of Leonora's cats when she moves to a retirement home. Who better to cat-sit than someone who was a cat in a previous life?

BETTY WHITE
─── ACTOR ───

With a sharp wit and mischievous glint in her eye, it's easy to see why Betty White has gained the status of a national treasure. The American actor and comedian first graced screens in 1939 and has stayed on them ever since, starring in iconic television shows such as *The Mary Tyler Moore Show* and *Golden Girls*. In 2013, she was recognized as the longest-working female TV star. But Betty has been breaking records and smashing glass ceilings for years. She was the first woman to produce a comedy sketch show, as well as the oldest person to ever host *Saturday Night Live*, at the sprightly age of 88. The secret to Betty's boundless energy and long life? "Vodka and hot dogs," the veteran comedian revealed.

Betty's love of entertaining is only surpassed by her passion for animals, which she claims began in the womb. Her parents had a ginger tabby named Toby, who liked to sit in her crib. Her mother always said that if Toby hadn't liked the baby, she would have had to go back to the hospital. Another beloved kitty in Betty's life was Mr. Bob, a Himalayan who turned up on her doorstep. She only meant to look after him for a few days, but Mr. Bob ended up staying for 11 years. Betty has been known to get her claws out for anyone who accuses cats of being uncaring—unless you have a cat, how can you know their true temperament?

> **BETTY HAS BEEN BREAKING RECORDS AND SMASHING GLASS CEILINGS FOR YEARS.**

Betty fondly recalls filming an episode of *Hot in Cleveland* with a litter of kittens. "We were all a mess. It was hard to get any acting out of us. We just wanted to play with the kittens." This silver-haired superstar was clearly in cat heaven.

"If there's ANYTHING more PEACEFUL than LISTENING to a CAT SNOOZING whilst PRESSED up AGAINST your CHEEK, I don't know it."

— Evanna Lynch, actor

Eartha Kitt
— MUSICIAN —

Eartha Kitt was an American performer who lit up the stage and screen with her sparkling, seductive persona. Born into poverty in South Carolina, Eartha's natural talent for entertaining led her into show business and a life of glitz and glamour. She was a multitalented performer, accomplished in dancing, singing, acting, and writing. Eartha also helped break down racial barriers in 1960s America by becoming the first black woman to achieve success on mainstream television. It's no wonder that actor Orson Welles once called Eartha "the most exciting woman in the world."

Eartha may just be the greatest cat lady who—most likely—never *actually* owned a cat. In the course of entertainment history, no performer has ever embodied the feline quite as perfectly as Eartha, starting with her distinctive "purring" singing voice. She was even described by the *New York Times* as "prowling" and "growling" on stage—like catnip for the audience.

It's no surprise that, because of this, Eartha was cast in several catty roles. In the 1957 Broadway play *Shinbone Alley*, she played an alley cat. And in the late 1960s she starred in her most iconic role of all—Catwoman in

NO PERFORMER HAS EVER EMBODIED THE FELINE QUITE AS PERFECTLY AS EARTHA.

Batman. The show's writer told Eartha, "You *are* a cat, you look like a cat, you act like a cat." The role, which saw her deliver a trademark growl, was Eartha's favorite to play. "It was fun," she said, "because I didn't have to think about her, I just did it."

When a café for cats was launched in New York in 2004, the owners could think of no one better than Eartha to formally open it. This sensational lady was undoubtedly *the* greatest Catwoman.

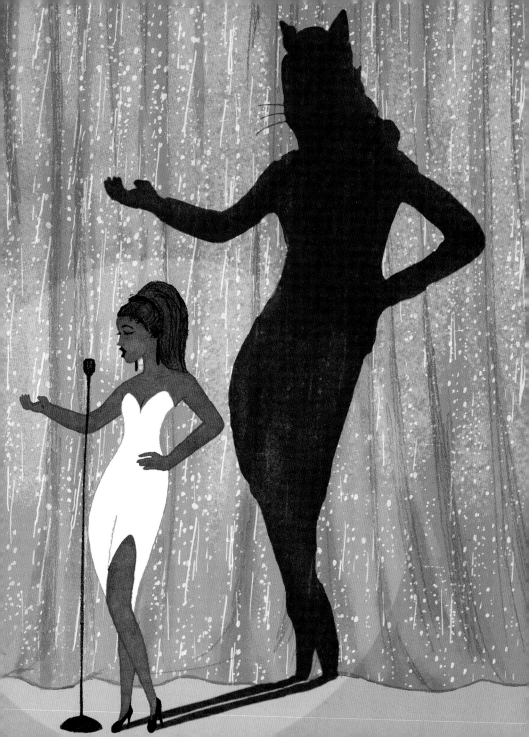

Joy Adamson
—— CONSERVATIONIST ——

In lots of ways, the tale of Joy Adamson and her cat is similar to that of many other cat owners. Coming across a stranded orphaned cat, Joy couldn't resist keeping it. She called it Elsa, and they went on to live together for many happy years. However, Joy's story differs from other cat rescue stories in one fundamental way. The kitten that Joy kept was, in fact, a lion.

In 1956, Joy's husband, George, a game warden in Kenya's Northern Frontier District, had come into conflict with a lionness, which he had been forced to shoot. It was then that he realized she had been protecting three cubs—now orphaned. He knew he couldn't just leave them, so he rescued the cubs and brought them home. Two of the cubs were passed to the care of a zoo, but the third was too small and weak. Joy took in the cub to raise it, and they developed a close bond. She reportedly confessed to Sir David Attenborough that she loved Elsa more than any man.

JOY TOOK IN THE CUB TO RAISE IT AND THEY DEVELOPED A CLOSE BOND.

Despite their connection, Joy knew that Elsa did not belong in captivity, so when the lion was strong enough, Joy returned her to the wild. In doing so, she pioneered the process of releasing an animal born or raised in captivity. Joy recounted Elsa's story in her bestselling book, *Born Free*, which was adapted into an Academy Award–winning film in 1966.

Joy went on to raise and release two more big cats: Pippa, a cheetah, and Penny, a leopard, proving that this caring cat lady wouldn't change her spots. Joy had an undeniable affinity with felines and can be considered to be more than just a cat lady—rather, she was a big cat lady.

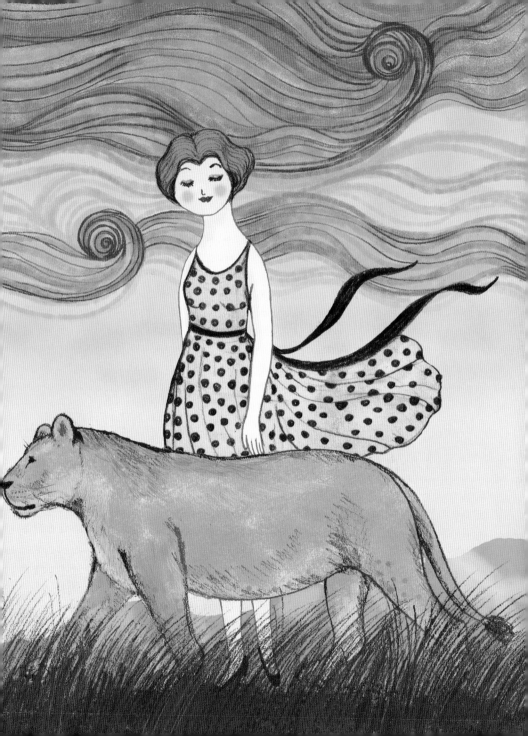

Audrey Hepburn
—— ACTOR ——

Known for playing one of cinema's most iconic characters in the classic film *Breakfast at Tiffany's*, this Hollywood star earned many accolades—as well as the occasional scratch behind the ear. Clearly this is not a description of the acclaimed British actor Audrey Hepburn, but rather her feline acting partner, Orangey.

The marmalade tabby already had a number of acting performances under his collar by the time he and Audrey worked together in 1961. He had gained a reputation within studios for being difficult and sometimes vicious, yet Audrey and Orangey formed a special bond during filming. Their partnership facilitated some of the movie's most memorable moments, including the climactic final scene in which Audrey's character frantically searches for the cat in the pouring rain. Audrey later described the moment when she had to toss Orangey out into the storm as the worst thing she ever had to do on film.

ORANGEY WAS ALSO QUITE THE TRENDSETTER.

Audrey is considered a timeless fashion icon and, like his costar, Orangey was also quite the trendsetter. In the weeks after the release of *Breakfast at Tiffany's*, pet stores and animal rescue shelters reportedly experienced a huge surge in demand for orange cats.

Following their collaboration, both Audrey and Orangey found great success. Audrey remains one of the few people in the world to have received Academy, Grammy, Emmy, and Tony awards. She was also presented with the Presidential Medal of Freedom for her work as a UNICEF Goodwill Ambassador. Meanwhile, Orangey starred in several more films and television shows and earned two PATSY (Picture Animal Top Star of the Year) awards during his acting career. A Hollywood tale of a great woman and a great cat.

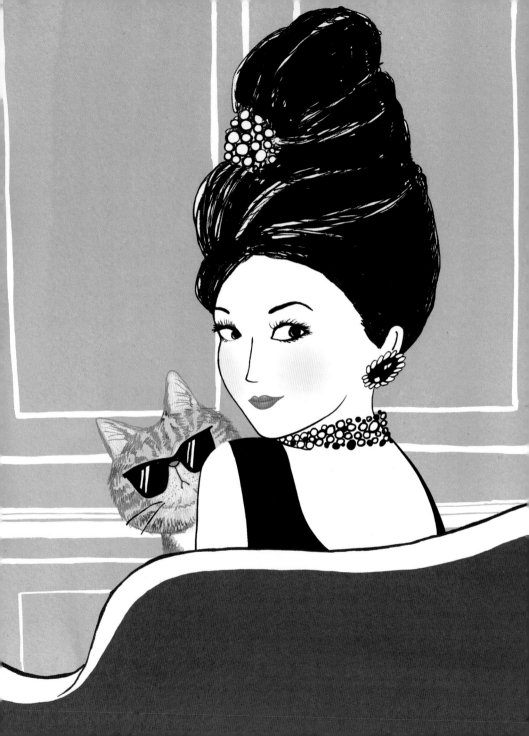

FELINE FACTS

Cats are more worldly than you might think.
The average house cat's genetic roots can be traced back to the
Middle East. One of the earliest ancestors to the modern cat appeared
in the Oligocene Epoch, between 34 and 23 million years ago.

Does your cat act like it's superior to you?
That's because, in some ways, it is. A cat's brain
contains more neurons in its visual cortex than a
human brain, and it can hear two octaves higher.

**A study found that cats know their names but
they pretend not to hear you when you call them.**
No wonder you sometimes get the feeling that your cat is ignoring you.

Cat's aren't nocturnal, as many people think.
They are actually crepuscular, meaning that
they are most active at dawn and dusk.

Purring isn't just a show of contentment.
The frequency of a cat's purr can help with tissue regeneration, bone
growth, and bone repair, helping them to hold on to those nine lives.

**Most female cats tend to be right-pawed, while
male cats are more likely to be left-pawed**.
This comes in useful for essential tasks such as playing with balls of wool,
hunting stray socks, and maintaining an exquisitely groomed visage.

Cats can tell the time.
Their brains register the position
of the sun in the sky, which is how
they know when to conveniently
appear for their dinner.

"I would FIND CATS in the STREET and TAKE them with me." - Penélope Cruz, actor

WANDA GÁG
—— AUTHOR & ILLUSTRATOR ——

Wanda Gág was an innovative American author and illustrator who created several classic children's books, including *Millions of Cats*, *The ABC Bunny*, and *Gone Is Gone*. Known for their dynamic illustrations and enchanting stories, Wanda's books are beloved by readers and critics alike.

In her hometown of New Ulm, Minnesota, there is a rather distinctive statue of Wanda. Cast in bronze, she sits cross-legged with a sketchbook in her lap and a pencil poised, studying a cat that sits in front of her. Wanda is sketching for her picture book, *Millions of Cats*, and the furry feline is believed to be Snoopy, Wanda's cat. The black-and-white kitty served as one of the models for the book, which tells the tale of an elderly couple's search for a cat companion.

SNOOPY WAS PATIENTLY POSING FOR WANDA.

Originally published in 1928, it remains the oldest American picture book still in print. In it, Wanda was the first artist to make use of a double-page spread, where an illustration unfolds as a scene over two pages, allowing the artwork and story to flow with movement. Consequently, the book earned Wanda two literary awards and numerous accolades.

While Snoopy was patiently posing for Wanda, little did he know that he was helping to create what would become a classic children's book and a ground-breaking artistic medium. Cats have become part of the literary canon, with some of children's best-loved characters being felines.

GIGI HADID
—— MODEL ——

As one of the world's top supermodels and a queen of social media, the world has gone gaga for Gigi. This star has taken over runways, billboards, and magazines around the globe. Her face has graced the covers of numerous fashion bibles including *Vogue*, *Harper's Bazaar*, *Glamour*, and *Elle*. In 2018, despite only being in her early twenties, Gigi was estimated by *Forbes* to be the seventh highest-earning model in the world.

She may live a life of privilege, but Gigi is passionate about helping others, one example being that she is a UNICEF supporter. She also uses her platform to draw attention to humanitarian issues such as the Rohingya refugee crisis.

GIGI PROMPTLY DID WHAT ANY SOCIAL MEDIA SUPERMODEL WITH A NEW CAT WOULD DO—SHE SET UP AN INSTAGRAM ACCOUNT FOR HER PET.

Gigi's concern for helping those less fortunate than her extends to those with four legs. She once took in a stray kitten, Cleo, who was found stuck in a car engine on a New York street. Gigi promptly did what any social media supermodel with a new cat would do—she set up an Instagram account for her pet.

Gigi dotes on Cleo, who often accompanies Gigi when she's out and about; she's even been on a luxury lunch date. She has often shared pictures of Cleo and her other cat, Chub, with her 47 million strong social media following. The felines have proved to be firm favorites with fans, with their cat snaps receiving millions of likes. Gigi Hadid is one of the greatest supermodels in the world and there's no doubt that she knows how to put the "cat" into catwalk.

FELINE HALL OF FAME

— SHORTEST CAT —

Standing at a mere 2¾ inches tall, the shortest ever cat was called Tinker Toy. He was an unusually tiny Himalayan-Persian and was a mini 7½ inches long.

— OLDEST CAT —

Creme Puff was a cat who definitely had more than nine lives. This Texan kitty was the oldest on record, reaching the grand old age of 38.

— TALLEST CAT —

At the dizzy height of 19 inches, Arcturus—a Savannah from Michigan—is officially the tallest feline on record. His owners also happened to have the cat with the longest tail (17½ inches). That's one record-breaking cat household.

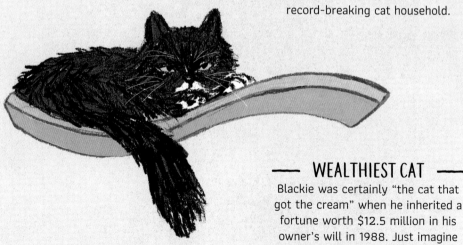

— WEALTHIEST CAT —

Blackie was certainly "the cat that got the cream" when he inherited a fortune worth $12.5 million in his owner's will in 1988. Just imagine all the catnip that would buy ...

MOST WATCHED CAT

The Internet is arguably man's greatest achievement—we now have access to hours upon hours of cat videos. The most watched of these feature Maru, a charming Scottish Fold from Japan. Clips of Maru have been viewed over 340 million times.

FIRST CAT IN SPACE

When Félicette boarded a rocket, it was one small step for a cat, one giant leap for feline-kind. In 1963, the French cat became the first to go into space. Naturally, she landed on all four feet when she returned to Earth.

GREATEST MOUSE CATCHER

If you're the type to squeal when your pet brings in its kill, just be grateful you never owned Towser, the greatest ever mouser. The tortoiseshell cat lived at the Glenturret Distillery in Scotland, where she caught an estimated 28,899 mice in her lifetime.

CAT WITH THE LOUDEST PURR

The loudest ever purr recorded was emitted by Merlin, a rescue cat from Devon, England. At 67.8 decibels, he was nearly as loud as a dishwasher.

ADA LOVELACE
—— MATHEMATICIAN ——

It is estimated that videos of cats have been viewed on the Internet more than 26 billion times. Perhaps this is exactly what cat-lover Ada Lovelace had in mind when she started designing the world's first computer program.

Ada, a British mathematician, is widely considered to be one of the most important figures in the early history of the computer. Working in the early 19th century, she is credited with imagining the full potential of the machine about a hundred years before one was actually built.

SHE SURELY WOULD HAVE LOVED THE PROLIFICATION OF CAT VIDEOS ACROSS THE INTERNET.

Her genius was evident from an early age. When Ada was just 12 years old she designed a steam-powered flying machine after being inspired by a bird that her cat, Puff, had brought home. Long before she was writing computer programs, Ada was writing tales of her cat's adventures. In one letter to her mother, she described how the mischievous Puff had taken her kittens up into the roof through a hole, where they were determined to stay. Ada imagined the cats sleeping among a tangle of cobwebs and could only conclude that Puff didn't possess very refined tastes.

Sadly, Ada didn't live to see the creation of the computer or the Internet. But if she had, she surely would have loved the prolification of cat videos across the internet. We should thank Puff for sparking the lifelong passion and curiosity for invention of this pioneering woman.

ELIZABETH TAYLOR
—— ACTOR ——

Famously married eight times, one love affair that never ended in Elizabeth Taylor's life was her passion for cats. The British-American actor and humanitarian once declared to *Rolling Stone* magazine that she was fascinated by these fabulous felines.

A star of the Golden Age of Hollywood, Elizabeth's role in *Cleopatra* made her the first actor to be paid more than one million dollars for a film. Off-screen, tumultuous romances made Elizabeth the focus of intense media attention. The actress sought solace in her Abyssinian cat, Cassius. In a letter to Cassius, after he had disappeared following their move to California, she wrote, "I remember the sweet smell of your fur against my neck when I was deeply in trouble ... You knew always when I hurt and you made comfort for me."

> ELIZABETH FINALLY MET HER MATCH WHEN SHE WAS IN THE COMPANY OF CATS.

The actor once described coming face-to-face with a black-maned lion in Africa. Ignoring the warnings not to look the big cat in the eye, Elizabeth bravely met his gaze. She later said that the two of them were staring into each other's eyes and that nothing in the world could have made her take her eyes off the big cat. Luckily, she survived to tell the tale.

It seems as though Elizabeth finally met her match when she was in the company of cats: they were just as passionate, fierce, and loving as her.

LEONOR FINI
— ARTIST —

One of the most important female artists of the 20th century, Leonor Fini was quirky, controversial, and totally original. Witty and charismatic with a fabulously glamorous dress sense, the Argentine-Italian artist was skilled not just in painting but also graphic design, illustration, and set and costume design. Her work is known for being dark and mysterious, and although she is often labelled a surrealist, she was never a member of that movement, nor did she identify with them.

Anyone looking through Leonor's extensive body of work will notice one subject crops up rather frequently: cats. Felines appear in her first ever paintings right up until some of her last. The artist apparently owned as many as 23 cats, which she allowed free reign of the house. It is said that Leonor shared her bed with her cats and let them wander the dining table at leisure when meals were served. For Leonor, living with cats was part of a long-term ambition. She had always wanted to live in a loving community—a big house with her friends, and more importantly, her feline friends, too.

LIVING WITH CATS WAS PART OF A LONG-TERM AMBITION.

Many of Leonor's paintings explore the relationship between men and women, and the women were often depicted as part-Sphinx. It is said that this feline figure—effortlessly elegant and completely unconventional—is representative of the artist herself.

DORIS LESSING
—— WRITER ——

Doris Lessing was a writer who was never afraid to tackle big subjects through her writing, whether it was politics, gender, race ... or cats.

Her life may have taken her around the world, but wherever Doris took her cats, it felt like home. Born in Persia (now Iran), she was given her first cat at the age of three. A few years later, her family moved to Rhodesia (now Zimbabwe), where they shared a farm with 40 felines. Doris later headed to England to pursue a literary career, where she continued to keep cats, writing about many of them.

> **WHEREVER DORIS TOOK HER CATS, IT FELT LIKE HOME.**

Her short stories "An Old Woman And Her Cat" and "The Old Age of El Magnifico" and her collections *Particularly Cats* and *Particularly Cats and Rufus the Survivor* are notable examples. Rufus the orange tomcat wasn't the only cat featured though. She also wrote about intelligent General Butchkin and the enormous, three-legged El Magnifico.

An author of more than 50 books, Doris is regarded as one of the most important writers of the 20th century. She was still writing in her late eighties, becoming the oldest ever recipient of the Nobel Prize in Literature in 2007. She was also still looking after cats: one of her own, called Yum-Yum, alongside numerous neighborhood kitties that would drop in from time to time—perhaps hoping to feature in or inspire Doris's next novel.

"MY CAT lived a very ROUGH LIFE before she arrived in my HOME. She has one TOOTH that's BROKEN... But I look at her and see the ABSOLUTE PERFECTION — the CHARMING PERFECTION — of IMPERFECTION. It gives me so much INFORMATION about the kind of LIFE she has had, and the kind of SOUL she has probably fashioned."

— Alice Walker, author

FLORENCE NIGHTINGALE
—— NURSE ——

Florence Nightingale is famous for being "The Lady with the Lamp," but she was also a lady with a lot of cats. Reported to have owned 60 felines throughout her life, Florence clearly cared for her four-legged friends as much as she cared for her patients.

Florence set up the world's first professional nursing school and wrote the seminal handbook *Notes on Nursing*. She is regarded as the founder of modern nursing, but almost didn't become a nurse at all. Her family opposed her chosen profession, believing her destiny was to become a wife and mother.

Florence earned her famous nickname during the Crimean War, when she made night-time rounds with her lamp to visit wounded soldiers. After she discovered a nest of baby rats, a soldier gifted her a small yellow cat, which often accompanied her on the ward and was responsible for driving out the pests. She believed cats had other health benefits, too: "A small pet animal is often an excellent companion for the sick, for long chronic cases especially."

FLORENCE'S LOVE FOR HER CATS ENDURED BEYOND HER LIFETIME.

Florence was bedridden intermittently from her late thirties onward, keeping a family of Persian cats for company. The cats would often knock over ink bottles, and trails of inky paw prints can still be seen on many of her papers.

Florence's love for her cats endured beyond her lifetime, as she made special provisions for them in her will. "Cats possess more sympathy and feeling than human beings," she once observed.

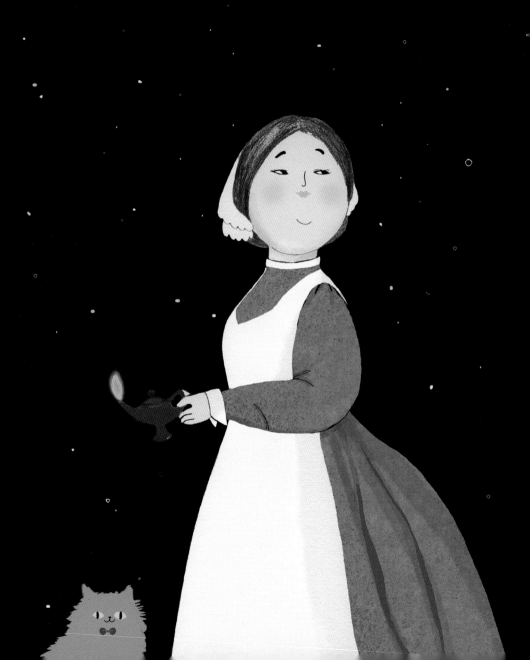

ANNA MAGNANI
—— ACTOR ——

Ciao, bella, to one of the greatest actors of all time. The magnificent Anna Magnani acted in over 50 films and is popularly known as the Queen of Italian cinema. Anna had a notably fiery nature and was reported by the *New York Times* to have a "Vesuvian" temperament. The American playwright Tennessee Williams once described her as "the most unconventional woman in the world." Anna was adored by the cinema-going public. In the cafés of 1950s Rome, it was said that you would always find two photos hanging on the wall: one of the Pope and the other of Anna Magnani.

CARING FOR THE LOCAL PUSSYCATS BECAME HER PERSONAL PASSION.

However, there were other famed residents of Rome competing with Anna—the humble alley cats. The ancient landmark of Largo di Torre Argentina, a site of Roman ruins, was home to many stray felines. Fortunately for them, Anna lived close by, and caring for the local pussycats became her personal passion. In a marked departure from her glamorous day job, Anna could often be found strolling through the ruins in her spare time, feeding the cats pasta and leftovers from the restaurants she frequented. The actor subsequently became known as Rome's most famous *gattara*, or "cat lady."

After Anna passed away, the cats were looked after by a succession of fellow *gattaras* from the arts, including an opera singer and another actor. Because of the devotion shown by these ladies, a colony of cats can still be found at the Torre Argentina today, where an official charity cares for their every need. Anna, the Queen of Italian cinema (and Italian cats), would undoubtedly approve.

JUDITH KERR
—— WRITER & ILLUSTRATOR ——

From an early age, Judith Kerr dreamed of a life surrounded by cats. As a child she longed for a feline friend but couldn't have one as her family were refugees from Germany, and they were constantly on the move.

Judith's feline dreams finally came true many years later, when she was a writer and illustrator living in London. She was watching her cat, Mog, one day when inspiration struck. Mog was such a peculiar and funny cat that she decided to create a picture book about her. *Mog the Forgetful Cat* was hugely successful and was followed by another 16 Mog books, which have enchanted children for over 40 years.

Judith owned eight cats after Mog, and their antics provided her with plenty of material for further cat books, such as *Twinkles, Arthur and Puss*, and *Katinka's Tail*. The latter is based on her cat Katinka, whom Judith described as "a ridiculous-looking white cat with a tabby tail that looks as though it belonged to somebody else." One of her most successful books,

"THEY'RE VERY INTERESTING PEOPLE, CATS."

The Tiger Who Came to Tea, took inspiration from a slightly bigger cat. Judith used to tell the tale to her daughter as a bedtime story. When she decided to turn it into a book, she visited the zoo to study tigers so she could illustrate them. Since its publication in 1968, the book has never been out of print, selling over one million copies.

Judith was at her desk writing books up to the end of her life, always with a furry friend by her side, of course. To her, cats were symbols of home, sources of inspiration, and constant companions. It's no wonder that she once observed, "They're very interesting people, cats."

CONVERSING WITH YOUR CAT

Cats are a lot more subtle in their expressions and body language than other animals. This handy guide will help you become a qualified cat whisperer.

When your cat lies on the floor and rolls over, showing its belly, your cat is saying, "Heyyyy. I'm, like, totally chilled out, man."

Contrary to what many people think, your cat is not begging for a belly rub. It's just relaxing and showing it trusts you. So don't risk scratching its tummy, unless you fancy being scratched back. The best thing to do is to give your cat a gentle rub on the head, as a sign of your deep affection, but also respect for its personal space.

When your cat decides to sit on your laptop keyboard, while you're typing, your cat is saying, "YAAYY! Isn't this GREAT?"

Your cat hasn't chosen this particular spot because it wants to hang out with you —sorry—or because it disagrees with that thing you just tweeted. It's because a warm, whirring computer is just a totally appealing place to sit. You should probably go back to using pen and paper, because your cat has just found a new, rather expensive, cat bed.

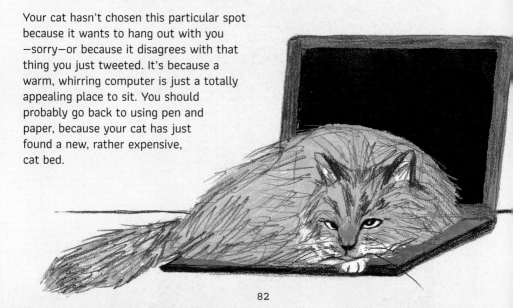

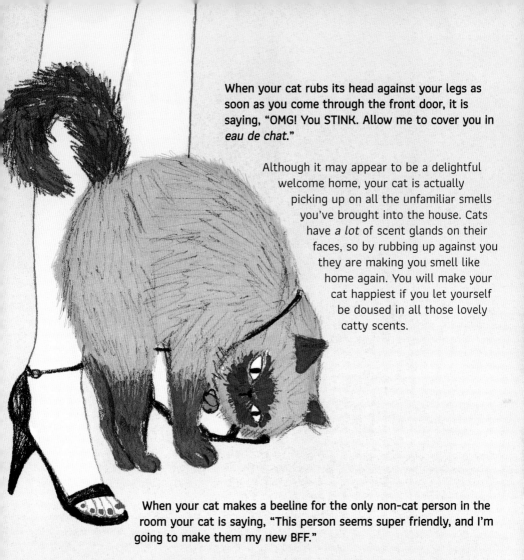

When your cat rubs its head against your legs as soon as you come through the front door, it is saying, "OMG! You STINK. Allow me to cover you in *eau de chat*."

Although it may appear to be a delightful welcome home, your cat is actually picking up on all the unfamiliar smells you've brought into the house. Cats have *a lot* of scent glands on their faces, so by rubbing up against you they are making you smell like home again. You will make your cat happiest if you let yourself be doused in all those lovely catty scents.

When your cat makes a beeline for the only non-cat person in the room your cat is saying, "This person seems super friendly, and I'm going to make them my new BFF."

Cats, somewhat like morning commuters, really don't like making eye contact with people they don't know. A non-cat person who has been studiously ignoring a cat's gaze will appear less threatening and more friendly, thus the cat will take a liking to them. The best approach would be to just like cats.

Josephine Baker
—— Entertainer ——

Dancer, singer, actor, spy—Josephine Baker had quite the impressive résumé. Born into poverty in the American Midwest, Josephine grew up to be one of the greatest stars of the 1920s.

Josephine began her show-business career on Broadway before moving to Paris, where she found fame and dazzled the city with her racy routines. She famously performed wearing only a string of pearls and a skirt made of bananas. *Oh là là*, indeed. Josephine swiftly became one of the most popular music hall entertainers in France and one of the highest-paid performers in Europe. A less well-known fact is that during the Second World War, the star added another string to her bow by becoming a spy for the French resistance, smuggling secret messages in her sheet music.

JOSEPHINE TOOK HER CHEETAH EVERYWHERE.

For a woman with such a big personality, only a big cat would do. To that end, Josephine was gifted a pet cheetah by the owner of a performance venue, who thought it perfectly matched her wild yet glamorous persona. Josephine could often be seen walking Chiquita, who would wear a diamond collar, on the streets of Paris. In fact, Josephine took her cheetah everywhere: in her Rolls-Royce, on holidays, to the cinema, and even to her performances. The big cat was known to occasionally cause chaos during shows by leaping into the orchestra pit. Like Josephine, Chiquita knew how to create a stir on stage.

In later life, Josephine retired to her château in the French countryside, where she lived with her 12 adopted children and, of course, her cherished cheetah, Chiquita.

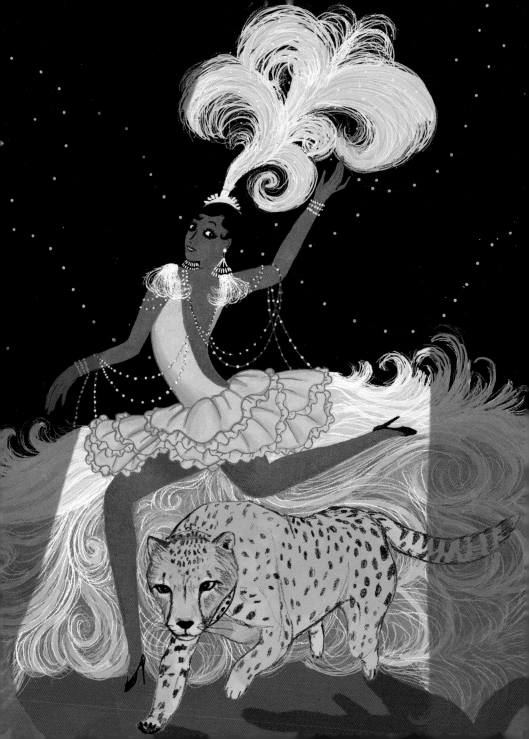

THE BRONTË SISTERS
—— WRITERS ——

In the picturesque Yorkshire village of Haworth, England, stands a quaint parsonage that was once home to one of literature's greatest families. Anne, Emily, and Charlotte Brontë lived in this house, along with the lesser known four-legged Brontës, Black Tom and Tiger.

Working within a whisker of cats clearly influenced the women's writing, with felines featuring in their novels on a number of occasions, particularly in Anne's novel *Agnes Grey*. The sisters' original and compelling narratives mean that their novels have never been out of print. Their books are known for their strong and passionate female characters, determined to live life on their own terms. This may be why the sisters had such an affinity for cats, given their independent and self-sufficient nature.

WORKING WITHIN A WHISKER OF CATS CLEARLY INFLUENCED THE WOMEN'S WRITING.

Emily Brontë once used her writing talents to publicly argue in favor of cats. In her 1842 essay "The Cat," she eloquently declared, "I can say with sincerity that I like cats; also, I can give very good reasons why those who despise them are wrong."

Visitors of Haworth parsonage today may be lucky enough to spot a cat prowling the gardens. If rumors are to be believed, it is a direct descendent of one of the Brontës' beloved pussycat pals.

TOVE JANSSON
—— ARTIST ——

Finnish illustrator, artist, and author Tove Jansson is considered one of the most successful children's writers of all time. She penned numerous novels and short stories, but is best known for the *Moomin* books, which have been loved by generations of readers since the first book was published in 1945. The tales of a group of adorable white trolls with large snouts have proved so popular that most houses in Finland contain some form of Moomin memorabilia. There is even a theme park in Finland called Moominworld, dedicated to the magical world of Moomins.

But the Moomins were not the only significant creatures in Tove's life. She had a dearly beloved black fluffball of a cat named Psipsina—the Greek word for "pussycat." A photograph shows the author lugging fishing nets on the Finnish coast, with Psipsina leading the way back up the beach, probably hoping for a morsel or two. Tove received thousands of letters from fans around the world and she would send back handwritten replies. For some lucky fans, she even included doodles of Psipsina.

WE MUST JUST LET CATS BE CATS.

Cats also made their way into Tove's paintings—in one of Tove's self-portraits, *Lynx Boa*, she has a distinctly feline gaze. Describing herself in this painting, she said "I look like a cat in my yellow fur, with cold, slanting eyes and my new smooth hair in a bun."

In Tove's novel, *The Summer Book*, the main character is terribly upset when her cat catches prey and leaves it around the house. The girl trades the pet for a docile lap cat, only to find the replacement rather dull, and she swaps back. Maybe the author was making a point about felines: we must just let cats be cats.

AGNÈS VARDA
—— DIRECTOR ——

"LIGHTS, CAMERA, ACTION ... CAT." It's just a guess, but this might have been how Agnès Varda began shooting her films.

This Belgian-born French filmmaker was a defining figure of the radical New Wave of French cinema in the 1960s. In a career spanning 60 years, Agnès made more than 50 films and documentaries. Her work is notable for telling stories about ordinary people in an offbeat, unexpected way. Blazing a trail for women filmmakers, Agnès was the first-ever female director to be given the Academy Honorary Award, for her extraordinary distinction in lifetime achievement. She also became the oldest nominee in Oscar history at the age of 89.

"THIS IS ALL YOU NEED IN LIFE: A COMPUTER, A CAMERA, AND A CAT."

If you watch Agnès's movies closely, you'll notice a rather furry theme. Several of her films feature feline cameo appearances, including by her own cats, Zgougou and Mimi. Even the logo of her production company features a tabby cat. You may not be surprised to learn that Mimi the cat proved to be as much of a cinematic star as her owner, winning the inaugural "Palme de Whiskers" award at the 2017 Cannes Film Festival. Critics raved about the cat's "spectacularly moving performance" in her owner's film, *Faces Places*.

When Agnès was nominated for an Oscar, she decided not to attend a lunch for nominees in Los Angeles, instead sending life-sized cardboard cut-outs of herself. According to reports, it helped to liven up a rather formal affair. This feisty filmmaker had a simple outlook on the world, once saying, "This is all you need in life: a computer, a camera, and a cat."

PURR-FECT PETS

Here are just some of the reasons that cats
are a match for fantastic females.

A SELF-SUFFICIENT CAT-TITUDE

Great women work hard and can frequently be found holed
up in boardrooms, studies, or studios for hours or days at
a time. The self-sufficient cat doesn't care. It can walk,
groom, and feed itself. Cats can take care of themselves,
while their owners take care of business.

UP ALL HOURS

Being a successful woman often isn't a 9 to 5 gig.
Inspiration and duty can call at all hours. Luckily, cats are active
day and night to provide constant company for 24/7 working women.

COOL CATS

If you want to make a scientific discovery or create an artistic masterpiece,
find a cat. They provide a calming presence, allowing their owners to get on
with achieving great things in peace.

A MUSE THAT MEWS

For creative people, having a compelling subject matter is essential. They
need a subject that is inspiring, fascinating, and beautiful. Did someone call for
a cat? Whether it's in literature, fine art, or film, felines have often inspired the
artistically inclined.

PAWS FOR THOUGHT

Many great women through history have chosen cats for companions.
But does the owner choose the cat or does the cat choose the owner?
Perhaps cats are drawn to great women because they sense similarities
with themselves: self-sufficient, up late, effortlessly cool, and endlessly
inspirational.